DSLR
PHOTOGRAPHY

THE BEGINNERS GUIDE TO UNDERSTANDING

EXPOSURE, APERTURE, SHUTTER SPEED,

AND ISO

Dalton Fairbanks

Table of Contents

Introduction ... 5

DSLR Advantages .. 10

- Ruggedness ... 17
- Number of glass elements that make up the lens 17
- Materials used in making those elements 17
- Whether or not the lens is corrected for aberrations 17
- Focal lengths ... 18
- Light gathering ability .. 18

Understanding Aperture .. 21

- Landscapes ... 23
- Portraits (casual): .. 23
- Portraits (formal): ... 23
- Macro photography .. 24

Understanding Shutter Speed ... 26

- Moving cars .. 28
- Moving water ... 28
- Moving people ... 29
- Moving lights ... 29

Understanding ISO ... 35

Understanding Exposure .. 39

- Illuminate your subject ... 48
- Show detail ... 48
- Light quantity .. 49
- Light color .. 49
- Light modification ... 50
- Light origin ... 50

Putting It All Together ... 52

- Landscapes ... 59
- Sports ... 59
- Animals and children .. 60
- Family get togethers ... 60
- Nighttime photography .. 60
- Leading Lines .. 61
- Framing .. 62
- Rule of thirds .. 62

Conclusion .. 64

☐ Copyright 2016 by Dalton Fairbanks - All rights reserved.

The follow eBook is reproduced below with the goal of providing information that is as accurate and reliable as possible. Regardless, purchasing this eBook can be seen as consent to the fact that both the publisher and the author of this book are in no way experts on the topics discussed within and that any recommendations or suggestions that are made herein are for entertainment purposes only. Professionals should be consulted as needed prior to undertaking any of the action endorsed herein.

This declaration is deemed fair and valid by both the American Bar Association and the Committee of Publishers Association and is legally binding throughout the United States.

Furthermore, the transmission, duplication or reproduction of any of the following work including specific information will be considered an illegal act irrespective of if it is done electronically or in print. This extends to creating a secondary or tertiary copy of the work or a recorded copy and is only allowed with express written consent from the Publisher. All additional right reserved.

The information in the following pages is broadly considered to be a truthful and accurate account of facts and as such any inattention, use or misuse of the information in question by the reader will render any resulting actions solely under their purview. There are no scenarios in which the publisher or the original author of this work can be in any fashion deemed liable for any hardship or damages that may befall them after undertaking information described herein.

Additionally, the information in the following pages is intended only for informational purposes and should thus be thought of as universal. As befitting its nature, it is presented without assurance regarding its prolonged validity or interim quality. Trademarks that are mentioned are done without written consent and can in no way be considered an endorsement from the trademark holder.

INTRODUCTION

Photography is a wonderful hobby. Pictures can capture the moments and memories we cherish. They can also help us revisit the places we've been, the people we've known, and the things we've done. There are many ways of improving your photography. Buying and learning to use a DSLR can certainly place you on the path to better images.

The following chapters will discuss the DSLR, its advantages for taking photos, explain the mechanics and uses of aperture, shutter speed, ISO, and exposure, and give you some useful techniques for making better images with this tool.

There are plenty of books on this subject on the market, thanks again for choosing this one! Every effort was made to ensure it is full of as much useful information as possible, please enjoy!

Let's start off by understanding the basic camera. "DSLR" is an abbreviation for "Digital Single Lens Reflex" camera. It is the digital successor of the "SLR" cameras used in the 1950s through the beginning of the 21 first century (and still used by some photographers).

The next part of the name "single lens" refers to the fact that the camera uses only one lens and that lens is "interchangeable," in other words, you can remove the lens and replace it with a different one. As obvious as this may sound, when this camera type first came out, its competition was another camera type known as the "TLR" or, "Twin Lens Reflex" camera. This camera was vertically oriented, shot a larger type of film, and had an upper and lower lens. The photographer viewed the scene through the upper lens and made the photograph using the lower lens. While this camera made great photos, it was a bit cumbersome, slow, had problems because the two lenses didn't align perfectly, and were challenging for beginning photographers to use.

The final part of the abbreviation, "reflex" refers to a mirror inside the camera. This camera reflects the image from the lens upward into the camera's viewfinder where the photographer views the scene. This mirror needs to move out of the way when the shutter button is pressed, hence the term "reflex."

In simple terms a "DSLR" camera is a camera that uses one lens, and has a viewing system relying on a mirror that reflects the image to a viewfinder and then moves out of the way when the shutter button is pressed. The last part is that it creates a digital image rather than an analog one.

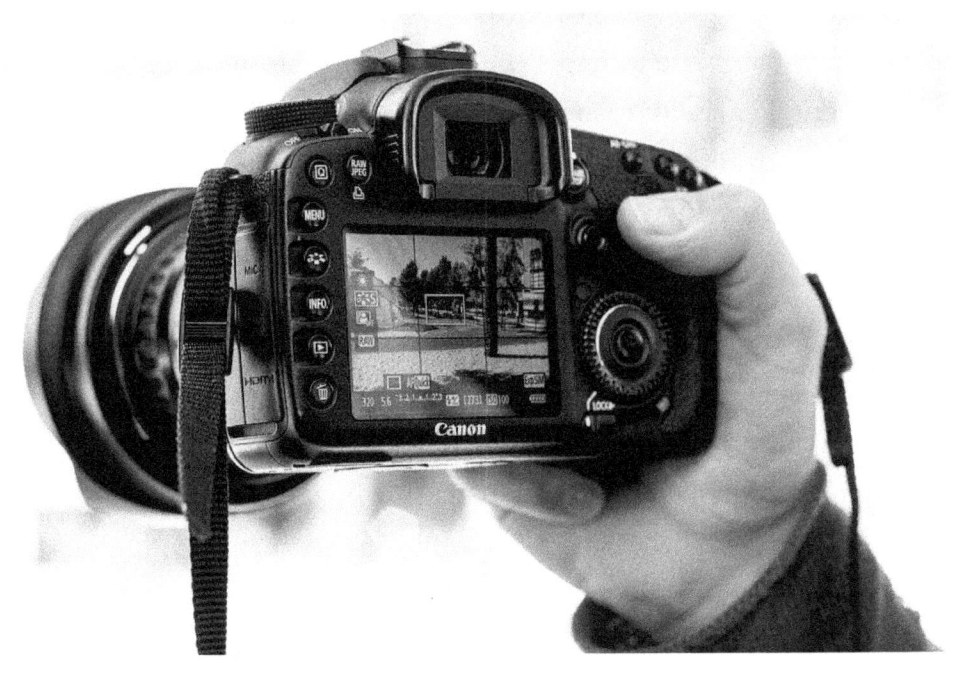

You may be wondering what the big deal is? After all, smart phone cameras are getting better and better. For many people, their smart phone cameras are all they need to take photos. Even wizened old photographers who grew up shooting film in the most basic of SLR cameras (ones that didn't even have electronics of any kind), will admit, "the best camera is the one you have with you when you need to take a photo." So why go to all the trouble and expense to buy a DSLR, lens, and accessories and then lug it around, when you could just use your smart phone?

They're right of course. It doesn't matter how capable a camera is if it's sitting home gathering dust when you get that great photo opportunity (or "opp"). But buying and using a DSLR doesn't mean you can't rely on your smart phone camera for casual shooting. The DSLR though offers some tremendous advantages over the smart phone camera. You'll get a better look at those advantages in the next chapter, but you'll get a big picture look here.

As good as smart phone cameras are these days; they still don't match the advantages an interchangeable lens DLSR does. These cameras offer better lenses, more versatility, and better quality. They can also a much wider range of lighting, weather, and other environmental conditions that smart phone cameras can't hope to match.

It's harder to make a good photo with a smart phone camera than it is with a DSLR. Smart phones are not designed to be held properly for photography. As small and convenient as they are, it's all too easy to get your thumb over the lens or cause the camera to move too much when the photo is being taken. The result is a "fuzzygraph," a picture that is unacceptably blurred.

DSLRs are masters of accessorization. In addition to being able to swap lenses as needed, they have an assortment of other tools available to help

them create the best possible images. Dedicated flash units, designed to communicate directly with the camera and with other similar flash units can make it possible for a shooter to recreate the kind of lighting found in photo studios in even remote locations.

But wait! There's more! (Sorry, couldn't help it.) Let's move to Chapter 1 and learn about specific advantages of the DSLR and start learning how to make better images.

DSLR Advantages

One big advantage of the DSLR over the point and shoot camera and the smart phone camera is quality. Of course "quality" isn't very precise now is it? You're wondering what exactly it means in the context of photo making technology.

It's a reasonably complex topic. Quality refers to multiple issues with cameras. For instance "professional" quality means something different to inexperienced photographers than it does to serious amateur and professional shooters.

A pro shooter for more than 30 years said, "When I look for a "professional" camera, I'm looking more for durability than anything else. In my busiest years as a sports and candid photographer I routinely shot more than 100,000 images annually and in a variety of conditions including rain, snow, dust, cold and others. My gear has to work."

A camera repair shop owner told the story of one pro lens he had to send to Canon for repair. When it came back, fully repaired and good as new, the storeowner told the lens owner:

"Your lens was full of sand," he said. "Canon was surprised at how much there was in it."

Three years earlier, the photographer had shot a story for the Army and Homeland Defense on a joint project they were doing in the Arizona desert to beef up the border. At one point he was standing under a helicopter that was lifting a concrete highway barricade and getting blasted by the sand it was kicking up. Neither camera nor lens was bothered in the slightest, and he kept shooting.

Three years later, he "bounce tested" (i.e. dropped) the lens on hardwood floor of my studio causing it to break in half. Even filled with sand, the lens had performed flawlessly with no loss of image quality or autofocusing speed and accuracy. Most of the time when camera equipment is designated as "professional" quality it is as much for its ability to take punishment, as it is for the quality it is capable of achieving.

Toughness and durability are one aspect of DSLR cameras and lenses. Another is the "quality" of the images you create. While the imaging sensors (the digital "film") of smartphone cameras are much better than they were a few years ago, they're still a lot smaller than those used in DSLR cameras. The typical DSLR camera has a sensor four or five times larger than the average smart phone camera. This is important because

the smaller the sensor the more the closely the photo diodes (think of them as the "cells" of the sensor) must be crammed. This causes greater heat buildup, which can cause those diodes to misfire resulting in poorer image quality. The technical term for this is "noise." This problem can lead to a poorer looking image whether you're getting prints made or simply planning on viewing the images on your computer screen.

DSLRs also help you improve your photography by giving you greater control of the image making process. This is because they offer greater flexibility than their smart phone counterparts. There are a wealth of controls and options available with a DSLR, much more than are available with a smart phone camera. This next section will introduce you to them.

The DSLR owner has plenty of options that aren't accessible to the smart phone owner (although there are some sad attempts at comparable tools on the market).

They can pick from a wide array of lenses, flash units, tripods, and other tools to help them make better pictures. Let's look at each of these.

Your smart phone may be capable of zooming in and out, but this is usually done by cropping the image and magnifying it. You can also buy accessory lenses that attach to the smart phone lens. The problem is these don't usually work very well (mine fall off all the time) and don't do

anything to improve image quality. They also tend to be pretty limited when it comes to expanding your smart phone camera's range. Here's a good rule of thumb: if you are changing your lens's focal length by placing something over the lens (such as an adapter telephoto or wide angle), you're hurting image quality. No camera or lens maker, produces a quality add on lens.

None of these things have to be a problem with a DSLR though. You can buy all sorts of accessory lenses ranging from super extreme wide-angle lenses all the way up to massive super extreme telephoto lenses. This means your DSLR will remain viable a lot longer than your smart phone will. Since today's DSLRs have imaging sensors capable of making high quality big prints (16x20 or larger for a 10 mega-pixel sensor), you can expect to get 4 or 5 years out of one quite easily, while most people replace their smart phones typically every 2 years.

The biggest challenges you face in choosing a lens or lenses is understanding what these optics can do and how you can use them to meet your photographic needs. In this part of the book, you'll learn about different lens categories along with some basic technical information to help you pick the right lens for you.

Let's start with lenses that give you a wider view of the world than the human eye does. These optics fall into a category known as "wide-angle"

lenses. Within this category are fisheyes, extreme wide-angle lenses, and wide-angle lenses. They can be either "fixed" focal lengths, lenses that only provide one field of view as compared to "zoom" lenses whose focal lengths can be moved from a wider to a narrower view. The more extreme the wide angle or the greater the zoom range, the harder it is to make a high quality lens, and the prices reflect that. If you're just beginning and don't yet know exactly what you want out of your photography, then starting with one or two inexpensive entry level zoom lenses can provide all the capability you need for just a couple of hundred dollars; even less if you're willing to take a chance on used equipment. If the time comes when you've learned enough to want better lenses, you can always sell your cheaper ones via eBay or Craigslist.

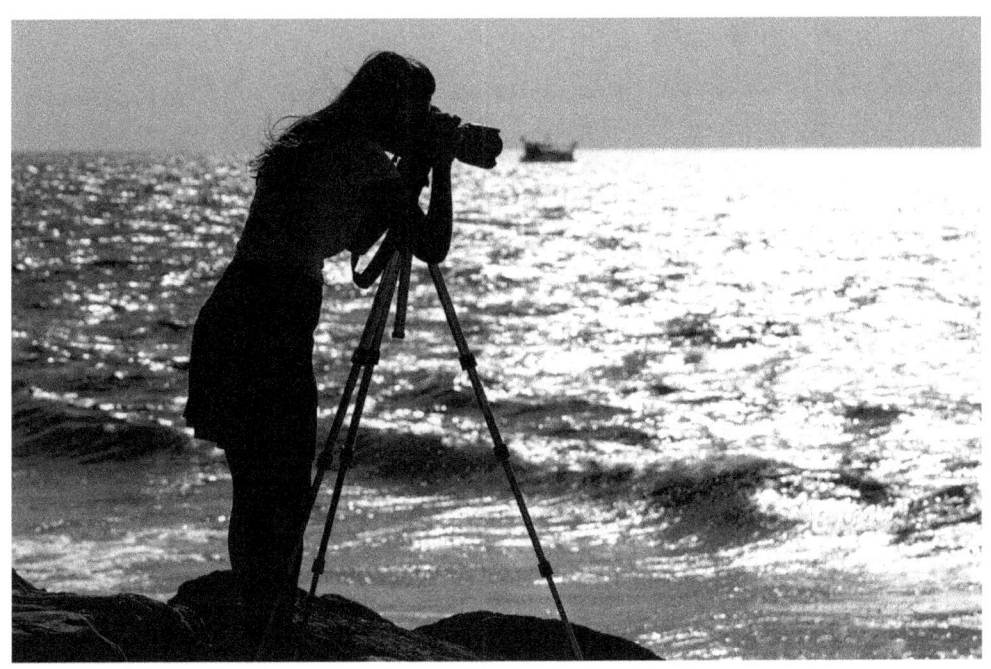

This is followed by the "normal" focal lengths group. "Normal" has several meanings when lenses are discussed. Originally, a "normal" lens was a lens that approximated the same field of view the human eye did. These days of course, a "normal" lens usually refers to a zoom lens that includes this focal length and extends beyond it in both directions. Since the 50mm focal length was usually considered similar to the human eye's view, it forms the basis of the "normal" lens type. Typical examples would be a 28-70/80mm zoom lens or a 35-105mm lens. Other variations are available as well.

Your third group of lenses is the telephotos. These can either be fixed focal lengths, such as a 300mm telephoto, or zoom lenses. A popular zoom lens telephoto is the 70-200mm, but 70-300mm, and 100-400mm zooms are also available. Even longer focal lengths are sold, but good ones are very expensive. You can find cheaper models, but the image quality they provide is usually poor at best.

A quick word on lens prices. You can buy a lens for under $100 or for as much as $16,000 or more. While it may seem ridiculous for such a price swing, there are valid reasons for one lens being much more expensive than another.

These reasons include:

- RUGGEDNESS – manufacturing a lens that can stand up to the abuse pros give it costs a lot more than making one for occasional photographers.

- NUMBER OF GLASS ELEMENTS THAT MAKE UP THE LENS – better lenses will have more glass elements

- MATERIALS USED IN MAKING THOSE ELEMENTS – while glass is basically sand, making the glass used in lens elements calls for a lot more than the stuff that gets between your toes at the beach. Manufacturing a pro quality lens calls for additives that drive the cost up. This is actually one place where you really can expect better image quality from a pro item than you can from cheaper lens.

- WHETHER OR NOT THE LENS IS CORRECTED FOR ABERRATIONS (flaws) caused by extreme focal lengths – Extreme lenses, whether they be wide angle lenses or telephoto lenses require extra elements and calculations to correct for problems that occur because of their extreme nature. Wide angle lenses have a tendency to aspherical aberrations, otherwise known as the "pin cushion" effect, curving the edges of the image away from the lens. Telephoto lenses on the other hand face the issue of "chromatic" aberration. Simply put, the red, blue, and yellow, light waves the lens records focus at different points once a lens gets beyond a certain focal length. While calculating the

right shape of the lens elements to solve this issue is a first year physics problem, the precision grinding of the lens elements and the addition of ingredients such as calcium fluoride drive up the cost significantly.

- FOCAL LENGTHS – the more extreme a lens focal length is, the fewer copies of that lens the maker is likely to sell. If you look at a lens maker's catalog, you'll often see a couple of zoom lens offerings that have two, three, or even four different versions of the same lens. These different "flavors" exist because the lens in question sells so well, it's worth the manufacturers time and resources to develop different versions for different needs. Economies of scale do play a role in lens pricing.

- LIGHT GATHERING ABILITY – If you've ever watched a major sporting event and noticed all the pro photographers carrying and using these massive lenses (often white or gray in color) and wondered about them, here's the scoop. Those really big lenses generally occur in the following focal lengths: 300mm, 400mm, 500mm, and 600mm. Notice, there aren't any zooms in that listing. So why are these lenses so big and so expensive (they cost thousands of dollars and more)? They're big because they gather a lot of light. Just like a high-end astronomical telescope is very big and very expensive, telephoto camera lenses have to get very big to gather as much light as possible. You'll understand this a bit better after the chapter on aperture.

The good news for new photographers though is that there is a lot of perfectly good equipment available at much more affordable prices. It's not designed to weather a sandstorm or get caught in the rain, but it will work perfectly well for the kind of conditions most novices prefer to shoot in. when you're starting out, a basic 18-55mm lens can usually be found for less than $100. A 55-200mm lens to compliment the 18-55mm can often be found for less than $200. Other zoom ranges such as 75-300mm or 80-200mm can be found for under $200 too.

Once you've gotten your camera and at least one lens, it's time to start learning how to use it. The first thing you need to work on is getting the hang of setting basic exposure controls and making sense of exposure. Since we've just finished talking about camera lenses, let's start out with the one exposure ingredient that the lens provides, namely the ability to control the amount of light entering the camera. Go to the next chapter to learn why this is important and how it works.

UNDERSTANDING APERTURE

"Aperture," "F-stop," "Lens opening." These are all terms for the same basic concept: how big is the opening the lens created to allow light to enter? Camera lenses use a set of diaphragm blades to vary the size of this opening to control the amount of light striking the imaging sensor (or film if you're old enough to remember using it).

Dealing with lens apertures (from now on this e-book will generally call them "f-stops" or refer to the lens "aperture") can be pretty confusing. For one thing, the smaller the number, the bigger the lens opening. For another, these settings represent a doubling or halving of the size of the lens opening depending on whether you're opening or closing it. Camera lens f-stops range from 1, 1.2, 1.4, 2, 2.8, 4, 5.6, 8, 11, 16, and 32. Each step of this progression represents a halving of the light striking the imaging sensor. You don't need to remember what you're about to read, but for those of you who are wondering why this is such a strange set of numbers, the lens f-stop is based on dividing the lens opening by the focal length of the lens.

Be forewarned, while there are lenses capable of really big aperture openings such as f1 or f1.2; they tend to be incredibly expensive and hard

to find. Lens focal lengths also affect the size and cost of the lens. A "normal" range zoom lens will generally be offered with a maximum aperture of f2.8 at the pro level, f4 for a still pretty expensive lens aimed at serious amateurs and what is known as a variable aperture zoom with f4 at the widest setting and f5.6 maximum aperture at the longest end of the zoom range. This means that the maximum f-stop available with the lens is different when it is at its widest position than it is when it is at its longest position.

Keep in mind, photographers use control of f-stops to do more than just allow light into the camera. The size of the lens opening can increase or decrease the apparent sharpness of your image. As a rule of thumb, the larger the f-stop number, the greater the "depth of field." Depth of field is the apparent range of sharpness throughout the image. Sometimes you want everything in the photo to be as sharp as possible, other times you want to isolate the subject of the image from the background.

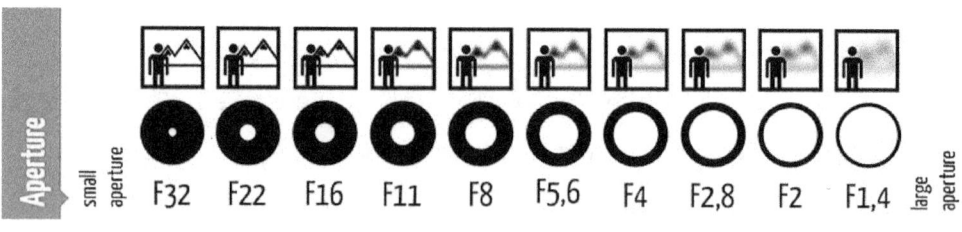

Here are a couple of examples:

- LANDSCAPES: generally landscapes call for as much depth of field as possible. A popular technique is to place an object in the foreground such as a rock or small bush and maintain sharp focus from foreground to background. This is done by setting a very small lens opening (f11 or f16 are good choices) and setting what is known as "hyper focal" distance. The goal here is to focus the lens to a point one third of the way from the foreground. The depth of field from the small lens opening will then carry all the way through the background to infinity. Keep in mind, you're probably going to want to put the camera on a tripod, wall, or other stable setting since using such a small lens opening will call for a longer shutter speed (explained in the next chapter).
- PORTRAITS (CASUAL): portrait photographers use depth of field at both extremes. For casual outdoor portraits they often use a telephoto lens wide open (f2.8 or f4) to throw the background out of focus while keeping the subject in sharp focus.
- PORTRAITS (FORMAL): depth of field plays a different role in the portrait studio or for formal outdoor portraits. Here the photographer typically wants to maximize the depth of field of the image, especially since he or she will use powerful flash units or continuous lighting systems to provide the light needed for such small lens openings.

- MACRO PHOTOGRAPHY: another rule of thumb is that the closer the camera is to the subject, the shallower the depth of field. In other words, if you're trying to take a close up of an insect, it will be hard to get the entire thing in sharp focus. Stopping down the lens to one of its smallest openings will increase the apparent sharpness of the insect for more of its length.

Another consideration when using a lens and setting an f-stop is what photographers refer to as the lens "sweet spot." As a general rule of thumb, this is a setting two to three f-stops from the lens's maximum lens opening. So if you're working with a lens that has an f4 maximum aperture, the sweet spot would be f8 or f11. Keep in mind, that while the sweet spot is the best choice for your lens, it doesn't mean you always have to try to choose that particular lens opening. It just means if other considerations don't drive your choice of f-stop, then strive to use the lens sweet spot lens opening.

Your camera will offer a specific auto exposure setting designed to help you mandate a particular f-stop under changing circumstances. This setting is usually referred to as "Aperture Priority" auto mode. When your camera is set to "A" (usually, but this can vary from camera to camera), you simply set the f-stop, and the camera will choose how long the camera lets light in to expose the image.

Keep in mind though, that relying on Aperture Priority auto mode can result in the lens opening up for too long a period of time for you to avoid blurring the image you're making because of camera vibration (more on this later in this e-book).

Now that we've covered aperture and its uses, let's look at how long the camera lets light in to expose the image.

UNDERSTANDING SHUTTER SPEED

In the last chapter you learned how the lenses opened and closed to control how much light hits the imaging sensor. In this chapter you'll learn another part of the recipe for a properly exposed photograph. The camera's shutter speed control lets you tell the camera how long the shutter is to remain open to allow light in.

There are very few things the average human being can register in fractions of a second. Photographers though work mostly in such short instances. Ask the average person to visualize 1/30th of a second and it's too brief a moment for them to consider. Ask a veteran photographer though, and he or she can probably nail it. And yet in photography, 1/30th of a second is consider a "slow" shutter speed. In fact, it's slow enough that most pros will consider using a tripod or vibration reduction technology when working with such a slow speed depending on the lens they're using.

But just as aperture settings do more than just determine how large the lens opening is, shutter speeds do more than just determine how long the sensor is exposed to light. While lens openings do much to control the apparent image sharpness via depth of field; shutter speeds can help

prevent blurriness in a photograph and also do much to help you depict speed and motion in an image.

Let's start with the importance of understanding the role shutter speed plays in helping create a sharp image. This control has nothing to do with focusing the camera or managing depth of field, but it does help prevent or cause blurriness depending on what shutter speed is selected. You see, too slow a shutter speed for the lens you're using will cause the camera to record any vibrations the camera suffers while making an exposure.

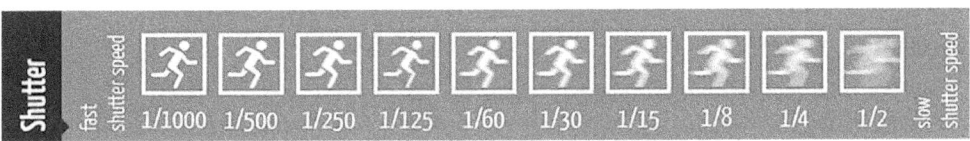

Photographers have a very rough rule of thumb called the "reciprocal of the focal length rule." Take the focal length you're shooting at – say 100mm and take its reciprocal: 1/100th. Now choose the closest shutter speed your camera offers that's faster than that. In this case set the shutter speed to 1/125th of a second. This should give you a reasonably safe shutter speed to prevent blur from camera shake. Bear in mind that this is just a guideline. If you're older, shakier, or had an extra cup of coffee this morning, you'll probably need to play it safe and go with an even faster speed.

Of course sometimes you can't chose a faster shutter speed. At times like this, you need to find some way of keeping your camera as steady as possible. Fortunately, you have a fair number of options including placing your camera on the ground or on a chair or a wall or some other stable platform. If you expect this to be a common occurrence, then you should consider buying a tripod. You'll learn more about tripods in chapter six "Putting it All Together."

Properly controlling your shutter speed can also help you make more interesting images that provide a sense of motion and movement. Slow shutter speeds (with the camera mounted on a stable platform) will let your subject blur as they move through the image. There are a lot of ways of using this technique. Here are a few:

- MOVING CARS – find a curving road and an elevated spot where you can set up your camera. Set a slow shutter speed, say about 2 or 3 seconds and trip the shutter as some cars are set to drive by. The slow shutter speed and the fast movement of the vehicles will blur the cars and record their taillights as ribbons of red and yellow.
- MOVING WATER – whether it be a river, waterfall, or waves crashing into rocks, moving water can be very beautiful when shot with a slow shutter speed. You may need an exposure of 15 to 30 seconds, but you can turn that moving water into spun glass this

way. Waves crashing on rocks with slow shutter speeds gain a cloudlike appearance, which also makes for spectacular photographs. (See photo below)

- MOVING PEOPLE – you can use a slow shutter speed (try several seconds) with your subject standing still as others walk or run by them. They'll appear as a pillar of calm amongst frenetic activity.

- MOVING LIGHTS – there are all sorts of artistic effects you can create by using a long shutter speed (5, 10, 15 seconds or more) and a light source or sources. Just wave the light source around in different patterns and you've created a light motion painting. Use colored LED lights or holiday lights and you can add all sorts of color to the scene.

Many DSLRs offer a feature designed to help you with avoiding blur from camera shake. Different manufacturers have different names for this feature (as you might imagine, the marketing department got involved in the naming process). Some call it "Vibration Reduction," some call if "Image Stabilization," but they all serve basically the same purpose. This feature may be housed in the camera body, or in the lens. If it's a lens based vibration reduction system, then you can't assume your lens has this feature unless your documentation says so. If your system has it in the camera body, then all you need to do is make sure it is turned on. There's not a big downside to using this feature.

There are other things you do with slow shutter speeds if you want to be really creative or solve lighting problems without resorting to a lot of expensive equipment. One of these is "painting with light." This technique has been around for decades, but it's much more easily done with a DSLR than a film camera.

Let's say you have to photograph a large structure and have determined nighttime is the best time to do so. Set your camera up on a tripod, then walk around the building area in view of the camera while using the self test button of your flash unit to "paint" the structure with bursts of light from the flash. You can then check the camera's LCD screen to see how well the technique worked. Plan on making half a dozen or more images this way to make sure you get it right. There's no sense in being stingy with exposures when you're using a DSLR!

Painting with light also works with human subjects, it's perhaps a little bit trickier though. Turn the lights off or go outside after dark, set the camera up on a tripod or other stable surface and position your subject in view of the camera. Trip the shutter and then use your light source to "paint" your subject with light.

Another interesting idea is to take some holiday lights and put them inside your car (you can tack or tape in various places), and, shooting

after dark, use a very slow shutter speed so the interior lights illuminate the inside with different colors. You can also paint the outside of the car with light to help illuminate it too. Outside houselights can also contributed to the scene's lighting depending on where you're doing the shoot.

Another good use of long shutter speeds is to remove unwanted people and moving cars from an image. Put your camera on a tripod, set an extremely long shutter speed (30 seconds or more), and trip the shutter. Because of the long exposure, moving objects will not be in sight of the camera long enough for them to register on such a long exposure. Keep in mind, you may have to block the light hitting the lens via what's known as a neutral density filter in order to get a long enough shutter speed during daylight. If you're working in really bright light, you might need to stack multiple neutral density filters.

How about creating "ghost" images? Yep. By using your shutter speed creatively, you can make your own ghosts. Just use another long exposure (between 5 and 10 seconds works well) and use a flash to illuminate your subject, who then leaves the scene. The brief burst of light from the flash will illuminate the subject while the long exposure will provide the light for everything else. You'll need to do some trial and error shots to get the right balance, but once you do, the rest is fairly easy.

There's another use for a slow shutter speed. It's called "panning." Ironically this technique calls for doing the opposite of what you've been hearing so far – emphasizing camera movement during the image making process rather than doing everything you can to minimize such movement. There's a good reason for it though. If you pan the camera with the movement of a runner (or a car or a horse or any other object moving perpendicular to the camera) with a slow enough shutter speed (1 or 2 seconds, maybe more), you can get a reasonably sharp image of your moving subject while completely blurring the background. This creates a sense of speed and movement in the photograph, as it appears the subject is moving very quickly. You'll likely need a trial and error approach and will have to make a lot of images to really get this technique right. You can also do it with the camera on a tripod that has a panning capability (many tripod heads do). You simply lock the vertical movement knob and unlock the horizontal movement knob so you can pivot the camera as the subject goes by you.

If you have a zoom lens, you can also try zooming in or out while the camera is making a long exposure (not the same time as you're panning though). You'll get better results with the camera on a tripod or stable surface, but it can work with the camera hand held, particularly if you fire a flash during the process.

Lest you think all shutter speeds should be as slow as possible, be aware you can also use extremely fast shutter speeds for wonderful creative

effects. For instance, as beautiful as moving water is at slow shutter speeds, it can be just as dramatic at extremely fast ones (1/1,000th of a second or faster). In fact, the most boring pictures of moving water usually occur at exactly the speeds most novice photographers shoot at!

Other reasons for using extremely fast shutter speeds include "freezing" motion. You need a shutter speed of at least 1/4,000th of a second to freeze a snake's flicking tongue (don't ask me how I know that, and I'm not suggesting you try it either). And as fast as that is, it still won't freeze a hummingbird's wings (or my friend reaching for the last piece of chocolate for that matter).

Do you want to freeze a baseball in flight towards the catcher's mitt? Figure 1/1,000th of a second should do it. The same if you want to catch the ball leaving the pitcher's hand. (Also, this is purely a timing shot. You can't expect to get this image by relying on your camera's motor drive.)

By carefully choosing a shutter speed you can add all sorts of drama or motion to a photograph. Try experimenting with extreme shutter speeds when you're out shooting. You may find they jazz up your photography.

Now that we've covered aperture and shutter speed, it's time to look into ISO. This is the abbreviation for The International Organization for Standardization. Now that you know that, you can promptly forget it. To

photographers, ISO, stands for something far more important. Turn to the next chapter to find out what.

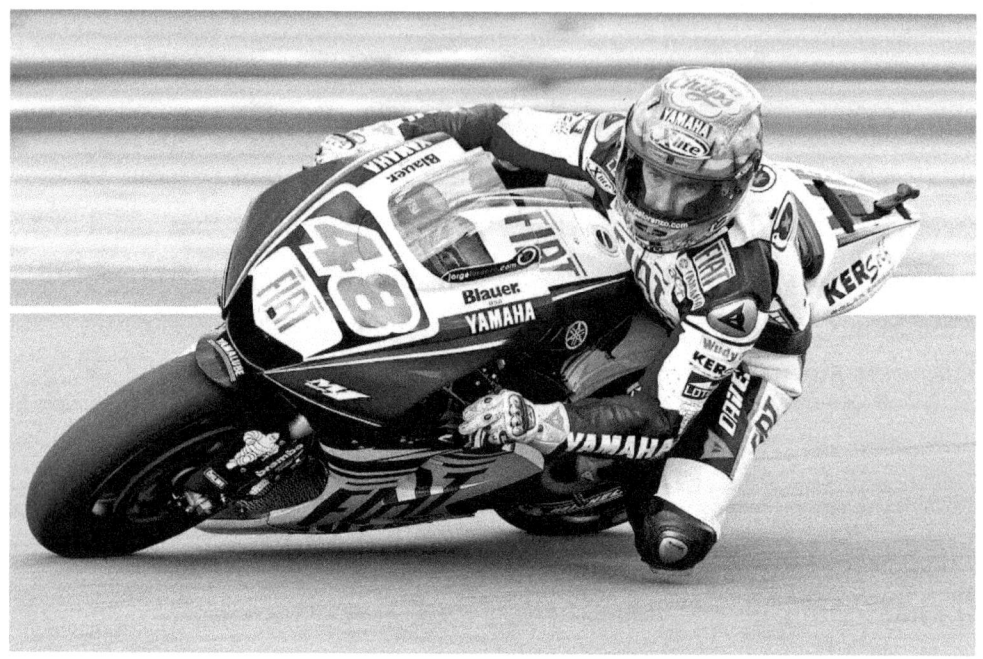

UNDERSTANDING ISO

If the camera's aperture controls the amount of light striking the imaging sensor, and the shutter speed controls how long the light strikes the sensor, then ISO controls the sensor's sensitivity to light (trust me, it does). You can dial the ISO setting down low (not very sensitive) or crank it up quite high (very, very sensitive), but as you might expect, there are trade offs to each approach.

Before we get to that, lets take a look at the technical side of ISO (not too technical though). Camera sensors are made up of millions of photo diodes (if you have a 6 megapixel camera for instance, then it has more than 6 million photo diodes). These diodes record certain colors (usually red, blue, and two versions of green). The camera's microprocessor then uses an algorithm to convert that information to the color you expected to see when you made the image.

ISO sensitivity is measured on a simple numeric scale. The lower the ISO number the less sensitive those diodes are to light. What's really important about this is that normally, the lower the ISO number, the better the image quality. This is because as you crank up the ISO setting, the hotter those photo diodes get. And, just like you get more extraneous

"noise" when you turn up the volume on a radio, you get more "noise" when you go to a higher ISO setting.

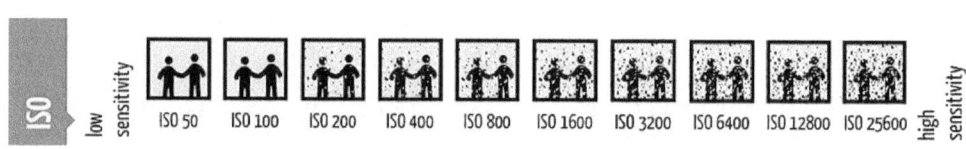

Each time you double the ISO number, you also double the imaging sensor's sensitivity to light. Photographers usually measure these changes in terms of f-stops gained or lost. So if you hear a photographer say "I picked up an extra f-stop by shooting at 400 ISO," he or she means they'd been shooting at 200 ISO and couldn't get the combination of f-stop and shutter speed to meet their needs, so they turned up the camera's sensitivity to light to increase the exposure.

These days DSLRs typically start with a low of 100 or 200 ISO and can reach a high of 25,600 ISO or more. While being able to shoot in very low light via a high ISO setting is nice, setting it all the way up at 12,800 or 25,600 will produce a very noisy image. In other words, some of those photo diodes will malfunction and instead of recording the actual color, record a different color. This can be particularly bad with the black areas in the image. Still, if the only way you can make the photo is by cranking the ISO all the way, go ahead. A "noisy" image is still better than no image after all.

Many DSLRs offer a "noise reduction" setting. While this can be very helpful, it, like many other aspects of photography, involves a trade off. While it can reduce the noise in your image, it often does so at the expense of image sharpness. At extreme ISO settings it can actually produce a muddy, soft photo.

There are also lots of apps on the market that specialize in reducing noise in images. This should give you an idea of just how pervasive the problem is in photography. The good news is DSLRs with their bigger sensors, generally produce less noisy images than smart phone and point and shoot cameras. Another bit of good news, at least if you've just purchased one, is that every time a new camera is introduced, it tends to offer improved noise handling ability.

While manipulating the camera's aperture and shutter speed settings can open up new worlds of creativity for you and lead to much more interesting photographs, controlling ISO is more about trying to achieve a balance between settings.

As a general guideline, your goal should be to keep your ISO as low as possible without interfering with your ability to create the image you've visualized.

So now that you've got a better handle on aperture (f-stop), shutter speed, and ISO, it's time to pull all these things together and understand exposure better. This includes introducing you to something known as "The Exposure Triangle," the dance between the three controls to produce the best possible image.

UNDERSTANDING EXPOSURE

At some point in this e-book, you might have thought to yourself, "Why can't I just let the camera make these decisions?" You can of course, and many of today's DSLRs are very good at making such decisions, but let's face it; if you've gone to all the trouble of buying a DSLR and reading this e-book (or vice versa), then you're probably trying to make better photos. As part of the process, you should consider taking command of the image making process. Your camera may be good, but it's not you, and can't know what you have in mind for the final image. Besides, you'll understand the process better and be able to manipulate better if you get some experience setting all three controls and seeing the effect each change has on the image.

A good learning exercise is to set you camera up on a stable surface and make a series of images where you adjust different settings so you can see exactly how each setting change affects the image. Within the view of the lens, set up three small objects (candy works well) each about an inch apart and in sequence progressing about 6 inches further from the lens for each piece of candy.

Take your initial exposure with the camera set to f16 and the ISO set to the lowest setting. Use the exposure dial (the one with the auto exposure settings) to set the camera to automatically set the shutter speed. Make a photo, then change the f-stop to f11 and make another photo. Keep repeating this process opening up the lens one full f-stop at a time until you get to the camera's maximum aperture. Turn autofocus off and manually focus the lens at the closest piece of candy.

Once done, take a good look at the images. You should see that as the lens openings enlarge, less and less of the scene is in focus. You can do the same thing with shutter speeds by setting the camera to aperture priority automation and having a moving object move across the camera's field of view. You can use a toy car or RC vehicle or find a cooperative human to help you out.

One problem with relying on your camera's brains instead of your own is that the "auto" functions of almost all digital cameras are based on providing images that will satisfy the average photographer. In other words, they're really designed to make "average" photos. Sure, many have special modes for sports, portraiture, landscape, and other types of photography, but even then, they still don't have the imagination a human photographer can bring to their photography.

Managing exposure properly is a vital part of the photographic process. But, creating a beautiful image requires more than just getting exposure right. You can have a properly exposed image, which is still pretty dull. If

you have a better understanding of the process, you can make better images. Let's take a closer look at what constitutes a proper exposure.

One of the first things to understand is contrast. In simple terms, "contrast" is the difference between the brightest white and the darkest black, with the exception of "specular" highlights. These are bright spots in the scene that are well outside the contrast range of the rest of the scene. Typical examples include reflections off of metal or water. By the way, "highlights" and "shadows" are terms photographers use in place of "bright spots" and "dark spots."

In order to make a properly exposed image, you need to be able to record details in both highlights and shadows (with the exception of specular highlights) and everything in between. The more extreme the contrast of the scene (think high noon on a bright, sunny day), the harder it is to do this. Sometimes, such as noon on a bright, sunny day, the contrast range is too great for the imaging sensor to handle, meaning either way too bright highlights ("blown out") or way too dark shadows ("blocked up") or even both.

A big advantage of DSLRs is just about all of them provide a tool known as a "histogram." This is a kind of chart that shows how pixels are distributed through the contrast range of the image (there may be color versions available on your camera too). Three sample histograms follow

this paragraph, one properly exposed, one over exposed, one under exposed.

You can use the histogram to get a more accurate reading of your image's exposure than you can from checking the LCD screen, particularly on a bright day. If all the pixels are within the boundaries of a histogram, you know you have an image that is workable. It may need some adjustments in an image-editing program, but those adjustments won't negatively affect image quality. If your scene it brighter than the camera can handle, you can either change your composition, block some of the light striking your subject or use a flash to put some light into the darkest parts of the scene.

Once you've gotten a handle on contrast, it's time to get a handle on the "Exposure Triangle." This is simply understanding that f-stop, shutter speed, and ISO are dependent upon each other in producing a properly exposed image that delivers what you expected it to.

The key point to remember is that once you've gotten a good exposure value that will give you a properly exposed photograph, you need to ask yourself if this combination of controls will create the image you envision. If not, then remember, as you adjust one control, you need to adjust at least one other control to compensate for the change you just made.

There's a delicate balance that goes on as you try to find the right combination of settings. Your general goal should be to shoot at the lowest ISO setting that allows you to function the way you want while shooting. If you need to get the maximum depth of field while hand holding your camera in poor lighting conditions, then cranking up your ISO to 400 or 800 ISO makes sense. Or, if you're shooting a basketball game in a poorly lit gym, then setting ISO to 1600 or 3200 in order to shoot with a fast enough shutter speed to freeze movement makes sense. It's better to have a sharp, noisy photography, than have a detailed out of focus or blurry image. Here's a list showing some typical priorities for common shooting situations. Each example lists the three elements of the exposure triangle in order of priority:

- Sports – shutter speed, ISO, f-stop
- Landscapes – f-stop, ISO, shutter speed (with tripod)
- Macro photography – f-stop, ISO shutter speed (with tripod or light)
- Candid portraiture – ISO, shutter speed, f-stop (largest lens opening)
- Formal portraiture – f-stop, ISO, shutter speed (tripod or studio lighting)

I should take a moment to point out this is all dependent on you working in manual exposure mode. As mentioned earlier, your DSLR will offer a variety of auto exposure modes including some designed to do all the work for you. If you just want to keep things simple, go ahead and use an auto mode (more on this in the last chapter), but if you really want to learn photography and make better images, getting the hang out of setting your own exposure will really help you.

You should also know, that no matter how smart your camera is, there are still conditions that can give it trouble. You've learned a lot about the elements of the exposure triangle so far, but there's another important ingredient in making an image you haven't heard much about yet – light. While the f-stop, shutter speed, and ISO controls help you set up for camera for proper exposure, it's the light striking the sensor that makes it all possible. Whole books have been written on understanding and using light, and it's been said the number of photographers who truly understand light can be counted with the fingers of one hand.

There are some basic concepts you can pick up in the next few paragraphs though, that will help you a good bit. A basic understanding of light needs to understand aspects of it that affect the image. These include:

- Light quality – light can be "soft" or "hard"
- Light direction – light can come from one direction or several

- Light quantity – the amount of light striking the sensor can vary tremendously

- Light color – even so called "normal" lighting usually contains some color to it

- Light manipulation – photographers often do things to change the nature of the light for their image

- Light origin – is it natural lighting, artificial lighting, or a combination of the two?

Let's start with light quality. As noted above, light can be either "hard" or "soft." Both types of light can be useful, just so long as you understand the difference and how to use each to best advantage.

"Hard" light is light from a light source that is very small in relation to your subject. Be aware, this doesn't mean the light source itself is small. The sun, a huge star, is considered a hard light source because it is very small in relation to anything here on Earth. A pencil torch on the other hand is huge compared to the speck of dust it's illuminating less than an inch away.

This type of light is considered "hard" because it is unforgiving and produces hard, clearly defined shadows and edges. It's great for showing detail (which can be unflattering for many of us).

"Soft" light on the other hand, comes from a light source that is very large in relation to what it is illuminating. A lamp placed next to a person seated at a table, will provide softer light than if that lamp is placed 5 or 6 feet away from them. A small flash unit positioned near the subject will provide a much softer light than if it is positioned a greater distance away.

Photographers have multiple ways of softening or hardening light. Light modifiers exist to do just that. You'll learn more about them in a few paragraphs. Moving a light source or moving your subject closer or farther from a light source will also help you control how soft or hard your light is. Another term for "softening" light is "diffusing." This simply means finding a way to spread the light out so it represents a bigger light source than it originally was. If you've ever seen a room lamp that directs its light up toward the ceiling so it reflects back downward, you've seen an example of diffused light. By pointing the light upwards so it reflects off the ceiling, the light spreads out (diffuses) and becomes softer and more flattering.

Light direction also plays a big role in influencing your final image. Light can travel in any number of directions. On a dark night, a flashlight will provide a very strong directional light, which functions in just one direction. A living room with a sunlight or two, plus a couple of house lights that are on, will provide light that's coming from multiple directions. Since some of that light will "bounce," or reflect, off of walls

and other surfaces, it increases the number of directions the light is coming from.

It's when you're dealing with a relatively precise light source that you can really use light to your advantage. This can be when the sun is low in the sky, or in a controlled environment such as a photo studio or house where you can position lights where you want them. Many photographers even off multiple off camera flash units outdoors to do the same.

A single directional light source can come from in front, to the side, behind, above, or below the subject of the photo. Each direction offers advantages and disadvantages. Add in a second light, and careful use of direction and you can do even more. Let's take a quick look at some of the things directional light can do for you.

- ILLUMINATE YOUR SUBJECT – a light placed directly in front of your subject will definitely show what the camera is looking at. It can also cause your subject to squint. This is probably the most common artificial light source approach simply because many cameras have built in flash units.
- SHOW DETAIL – lighting your subject from the side is an excellent way to bring out the detail in it. Photographers often use two lights, one from each side for macro or close up photography. For best results you can position the lights at 45-degree angles to

the subject. Keep in mind, you don't need to use expensive professional photo lights. You can simply use whatever lights you have available.

- LIGHT QUANTITY – when the average person thinks about light quantity, it's usually a simple binary question of "is it too bright or too dark in here?" Photographers are far more obsessive on this particularly important topic. Your camera has a built in light meter, which measures the light reflected off your subject. You can measure light quantity in terms of f-stops and make a judgment as to whether you have too much light or too little with more precision than "too much or too little." As a photographer you can also choose to add or block light, as you feel necessary. Many DSLRs actually offer a choice of light metering approaches. You'll need to check your owner's manual to see which ones your camera offers and how to use them.

- LIGHT COLOR – yes, many pro photographers also worry about light color and actually have tools to measure the color of the light falling on their subjects (the good news is that you don't need to buy one, your camera does a pretty good job judging light color). You might find this surprising, but "white" light is rarely "pure" white as far as your camera is concerned. While the human mind makes adjustments and "corrects" for color when assuming a light source is supposed to be "white," your camera tries to do the same, but generally not as well as the human brain. Incandescent lights often have a bit of a yellow cast too them, while fluorescents

a touch of green (although they've gotten much, much better over the years). During the course of the day, the light from the sun can vary in color from reddish to orange to yellow to white and back. If you come across the term "White Balance," it refers to the camera either being told (by you) or figuring out on its own, what "white" really is in the scene you're photographing.

- LIGHT MODIFICATION – many photographers are control freaks and find that controlling every aspect of the photo process is part and parcel of the photographic process. Light modifiers are tools photographers use to shape, redirect, soften, or spread out the light. These can include tools such as umbrellas and soft boxes to soften the light, or snoots and barn doors to shape the light. While the ones the pros use can be pretty expensive, you can often use things you already have to achieve similar effects. Simple things such as a piece of foam board or those silver reflectors you use to block sunlight from heating up your car, can be used to redirect light into shadow areas or block light in areas of the scene where the light is too bright.

- LIGHT ORIGIN – being aware of your light source's origin can be pretty important. You can be using artificial light or sunlight or a combination of the two. If you do, you have to look at whether they work together or not. Often, you can reposition either your subject in relation to the sun, your artificial light, or both subject and light.

You have a lot more to learn about using light, but this e-book has a word limit far short of what is necessary to really cover the topic, so it's time to move on to the next chapter, which talks about putting it all together to get good results with your DSLR.

PUTTING IT ALL TOGETHER

While making a photograph can be as simple as turning your camera on, lifting it up, pointing it at something interesting, and pressing the shutter. Of course, this isn't really a recipe for memorable photographs. If you want to make better images, you might think about trying some of these approaches.

Consider you camera orientation. Because DSLRs are generally horizontally oriented, the overwhelming majority of photos made with them tend to be horizontal in nature, yet much of our world is vertically oriented. When possible, get in the habit of taking the same photo at least twice, one horizontal, and one vertical. It's also a good idea to try to make some images from different vantage points. Get your camera down at ground level or up high from time to time. Ask yourself if perhaps moving to a different position could also provide you with a better image.

Also, try to learn how to hold your camera to keep it as steady as possible. Many DSLRs still include a viewfinder of some kind. It's better to press the camera to your face and brace your elbows against your body than it is to hold the camera at arm's length before pressing the shutter. Also, try to be as gentle as possible when you press the shutter button. Even slight

vibration when pressing the shutter button can cause a loss of sharpness in an image.

Many people look at autofocus as the solution to soft photographs. The reality is that autofocus alone is no guarantee of a sharp photo even when it does do what you want it to (and it doesn't always do that). Blur from camera shake is actually a bigger cause of fuzzy images that focusing mistakes. Atmospheric haze can be another factor, as can subject movement, or low contrast light.

Consider the light. What direction is it coming from? Is there enough? Is it hard or soft? Does it need to be modified, redirected, or augmented? It can be hard for a novice to visualize these things because the human eye is so superior to the camera's imaging sensor. This is another way a DSLR is so helpful. You can review the image on the camera's LCD screen and via the histogram. Look at shadows on your subject. Do they need cleaning up? You can use the camera's built-in flash, an accessory flash, or a reflector to redirect some light into those shadow areas. A simple piece of foam board can do the trick, or you can buy a collapsible reflector at an online camera store or via eBay. You might even consider coming back at a different time of day when the light might be better.

While you're thinking about light, keep in mind that normally the best light of the day occurs from about half an hour before sunrise till half an

hour past sunrise and the same goes for sunset. At these points of the day, the sun is low in the sky producing interesting shadows, and more importantly, beautiful reds, oranges, yellows, and even pinks. Granted, there's no guarantee every sunrise or sunset will turn out beautifully, but when it does, you'll get a great image.

Rather than play a guessing game when planning a sunrise or sunset shoot, you have some resources online that can help you out. Any weather website can tell you what time sunrise or sunset will be for instance. Many photographers are fans of the http://photoephemeris.com website, which provides detailed information on sunrise, sunset, and more. You can download a free desktop version. There are also versions of the app for mobile devices, but these will cost you about $10 each.

It's helpful if you know what kind of subject matter you're interested in. You may also want to consider whether your current gear is sufficient or do you need to invest in more gear (This is a trick question. Ask any photographer and the answer is always "Yes!")

Let's say you're interested in landscape photography. You can get by with a basic DSLR and lens, plus a willingness to put your camera on the ground or on a flat surface, but there are accessories you can get to make your job easier.

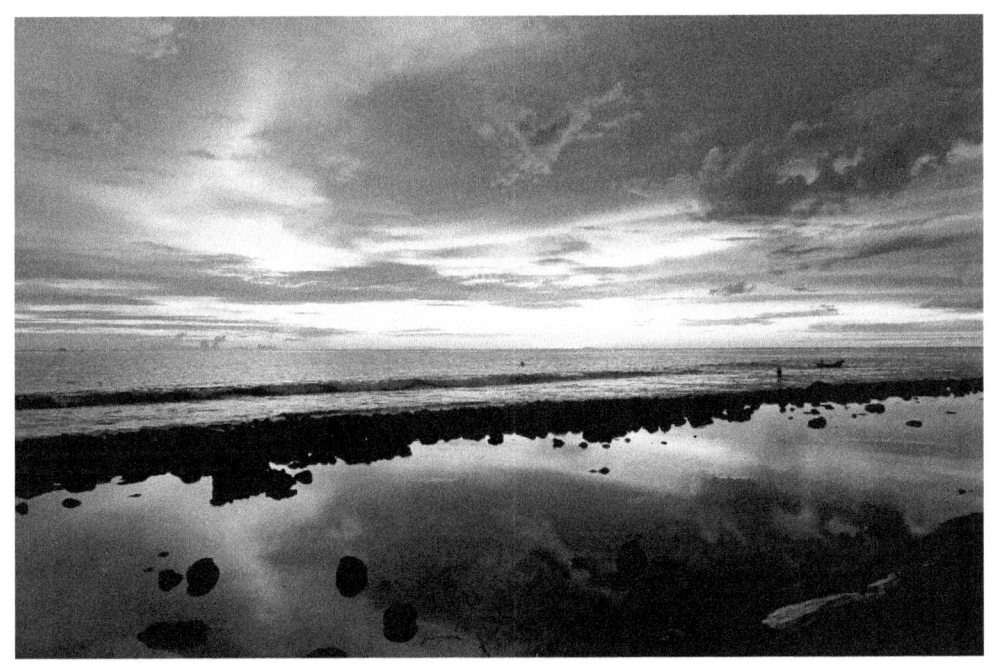

A tripod is a good all around investment. While good ones can cost hundreds of dollars, you can get a decent one for under $100. Stay away from tiny tripods that claim they can extend to four or five feet in height. These aren't stable enough to do you any good. Look for a three- or four-section tripod that can extend to three or four feet without raising the center column. You'll also find a wide-angle lens useful, as well as either a remote shutter release or an app to wirelessly trip the shutter. Either of the last two will minimize camera vibration from the shutter firing as compared to trying to press the shutter button with your finger. If you do have the budget for a really good tripod, 3 Legged Thing (https://www.3leggedthing.com) makes some very nice ones.

Another worthwhile investment is an accessory flash for your camera. You're much better off with this than the camera's built in flash, which is really only good over short distances and isn't very versatile. Many camera systems offer what are known as "dedicated" flash units. These units communicate with the camera to produce the best possible exposure. Many of them can work with the camera even if they're not attached to the camera. While ones made by the camera manufacturer are the best choice, there are lots of third party choices that also work well. Another consideration is a continuous light source. While these aren't popular for fieldwork, they can be useful indoors. Many photographers working on a tight budget will even use an inexpensive set of work lights for their photography.

As you assemble your photo kit, you'll need something to carry everything in. While there are a ton of bags available on the market specifically designed for cameras and equipment, there's no rule that says you have to use such a bag. If your budget allows, bags from www.Mindshiftgear.com are excellent. If you need to pinch pennies, then worry more about the padding inside to protect your gear than the name on the outside of the bag. A modest knapsack with some strategically placed padding or lens bags can do the job quite nicely. You can do the same with a decent fanny pack if you're only carrying a few small things like extra batteries, memory cards, cleaning cloth, and flash if you're carrying one.

By the way, try to avoid a very common novice error, fear of intimacy. Well, actually it's the tendency to compose a photo too loosely. How often have you seen a photo of someone that seems like it was shot from a long distance? There's a saying in photography, "feet don't show emotion." Move closer or zoom in closer and fill the frame with your subject. I can pretty much guarantee it. You've been shooting your photos too loosely. It's time to break that habit.

Another useful bit of advice is to try and use your DSLR a lot. Becoming a good photographer takes practice. Keep in mind, just pressing the shutter button over and over is no guarantee of good images, but a camera that sits in the closet gathering dust doesn't help a photographer improve either. Try to plan photo outings from time to time with specific ideas in mind. Here's a list of some ideas and advice you can use:

- Portraiture -- Take a friend(s) or loved one(s) out for a candid portrait session in the local park and think about how to light them, how you want them to pose, and what time of day will work best. An overcast day can be really good for this because the cloud cover will soften the light greatly. As a rule of thumb, longer focal lengths (80mm and longer) are more flattering for portraits than wide-angle lenses are (they can create a funhouse mirror effect). If you're dealing with a cloud free, bright, sunny day, then look at posing your subject in the shade rather than having them stare into the sun or pose with the sun behind them.

- LANDSCAPES – find a local park or scene you find interesting. Try photographing it at sunrise or sunset. Wait until the sun has dipped at least partially below the horizon. If you try to shoot with the sun above the horizon and are facing into it, the light, particularly with the magnification of the lens, can damage your eye. Once the sun begins to drop below the horizon the light should become more colorful. At the very last (or at the very beginning in the case of sunrise), you may be lucky enough to get some really vibrant pink light.

- SPORTS – this is a single word that covers a huge variety of activities so it's not easy to provide on the money advice. Here are some things to consider though. Use fast shutter speeds to freeze action, and then slow ones to show motion. Don't forget that sometimes the most interesting shots occur when the athlete is just about to begin their movement or just after they've completed it and seen the results. Also, anticipate action. In baseball or softball, you know the action begins with the pitcher. Take shots of the pitcher preparing to throw the ball or as they throw the ball. For swimming, the start of the race is very predictable. Try to time the shot for just as the swimmer leaps into the water. Another good moment is when they're swimming towards you (if you can get down by the pool). If they're swimming the backstroke, see if you can get up high and shoot down on them. The idea is to visualize things that are predictable and put you in a position to make the best photo.

- ANIMALS AND CHILDREN – sorry to lump them together, but they have a lot in common. For a start, they're both low to the ground and all too often get photographed looking up. You'll get better photos if you get down to their level and photograph them eye-to-eye. For another thing, they can be pretty uncooperative simply because they may not understand what's going on. Patience is an important ingredient in this kind of photography. Give either the chance to get used to your presence and the sounds of your camera and your flash (if you're using one) going off. Once they become a bit more relaxed, you'll get better photos. It helps if you can get them playing. They'll forget you're taking their picture and will have pretty interesting expressions too.

- FAMILY GET TOGETHERS – while group photos are popular at this kind of thing, candid photos are where the really memorable images can be found. This calls for some stealth and movement, plus you end up being more of an observer than a participant. Of course nothing says you have to spend the whole event working as a photographer. Just plan ahead a bit so you can figure out when ideal shooting stretches will occur.

- NIGHTTIME PHOTOGRAPHY – the night can provide you with some wonderful photographic opportunities. You can take advantage of streetlights and lamps coupled with long exposure to create some very interesting images. It's even better if you go out after a rainstorm since the water on the roadway combined with the light from the lamps will create interesting reflections.

These are just a few of the possible ideas you can play with in an effort to make better photographs. Photography is one of those things where regular practice can lead to significant improvement. Just remember it takes more than just taking a lot of pictures; it also takes thinking about what you're shooting and asking how you can do things differently, how you can try new techniques, and how you can be a better photographer.

DSLRs may not have the small size of smart phones, but they're capable of much better results, offer much greater capabilities, and give you much better choices than those phones.

Finally, let's consider how to arrange the elements of your photograph. This is known as "composition," and it's an important aspect of photography. As a general rule of thumb, you don't want to waste space in the image frame. Beyond that there are some basic concepts photographers use. These include:

- LEADING LINES – you can often find lines in a scene. Using these lines can move the eye through the photograph. For example, imagine a set of railroad tracks pointed away from you. These lines pull the eye deeper into the scene and focus the eye on anything on those tracks in the distance. Any kind of line can be used to direct the eye, even a line of people or automobiles.

- FRAMING – you can use all sorts of naturally occurring objects to help create a full or partial frame around your subject. A common example is using the trunk of a tree and one of the branches to form an "L" shape around a person or thing. Windows also make excellent "frames." This technique not only directs the eye where you want it to go, but it also serves to add a sense of depth to the image.

- RULE OF THIRDS – imagine dividing your frame into horizontal and vertical thirds. Place your subject, or the most important part of it (such as the eyes in a portrait), at the intersection of one set of these lines. If you're depicting a moving object, make sure you give it plenty of room to move into the image rather than out of it.

CONCLUSION

Thank for making it through to the end of *DSLRs for Beginners*, let's hope it was informative and able to provide you with all of the tools you need to achieve your goals whatever it may be.

The next step is to go out and start working on improving your photography and making great images. Don't get discouraged if it seems to take a while. Often the creative process demands fits and starts before improvement becomes recognizable.

One excellent pro photographer had what he called his "Minimum Daily Requirement." Every day he shot at least one roll of film. It was how he kept his photographic skills sharp and improved on them. You don't have to take 36 shots a day, every day, but getting out (or staying in for that matter) and working on making good images will help you become a much better photographer.

Also, get in the habit of ruthlessly culling your mistakes. One of the big differences between a professional photographer is that amateurs show you their mistakes, pros don't. A beginner will show every single image

they've made in a shoot, where a pro will just show you the one, two, or three very best images.

Once you've determined what images you like best, consider getting them printed and framed. Go with a decent sized print, at least 5x7 in size, but 8x10 or 11x14 is better. Hang them on your wall where both you and your guests can enjoy them.

Finally, if you found this book useful in anyway, a review on Amazon is always appreciated!

www.ingramcontent.com/pod-product-compliance
Lightning Source LLC
Chambersburg PA
CBHW070134210526
45170CB00013B/1008